Cobalt blue

Crimson lake

White

The
PASTEL
PAINTER'S
POCKET
PALETTE

Practical visual advice on how to
create over 600 pastel colors
from a small basic range.

Cerulean blue

Rosalind Cuthbert

Cadmium yellow

Viridian

NORTH LIGHT BOOKS

Cincinnati, Ohio

A QUARTO BOOK

THE COLORS

Copyright © 1992 Quarto Publishing plc First published in the U.S.A. by North Light Books, an imprint of F & W Publications, Inc 1507 Dana Avenue Cincinnati, Ohio 45207

ISBN 0-89134-482-9

This book was designed and produced by Quarto Publishing plc The Old Brewery, 6 Blundell Street London N7 9BH
Senior Editor: Hazel Harrison
Senior Art Editor: Ashleigh Vinall
Designer: Kerry Davies

Art Director: Moira Clinch
Publishing Director: Janet Slingsby

Typeset by The Brightside Partnership Manufactured by Bright Arts, Singapore Printed by Tien Wah, Singapore

page 12
Lemon yellow
tint 6

page 16
Cadmium yellow
tint 4

page 30
Crimson lake
tint 4

page 36
Purple
tint 4

page 48
Viridian
tint 6

page 54
White
(cream shade)

page 58
Cool gray
tint 4

Whilst every care has been taken with the printing of the color charts, the publishers cannot guarantee total accuracy in every case.

CONTENTS

page 22
Cadmium orange
tint 6

page 26
Cadmium red
tint 6

page 40
French ultramarine
tint 8

page 44
Cerulean blue
tint 4

page 64
Burnt sienna
tint 6

page 68
Ivory black

USING THIS BOOK 4

OVERLAYING AND
BLENDING COLORS 6

ABOUT PASTELS 7

GREENS 8

SKIN TONES 10

USING
COMPLEMENTARIES 20
Oak in Winter

THE COLORS OF
SNOW 34
Sun and Shadows

USING GREENS 52
Cypresses, Fiesole

USING MUTED
COLORS 62
Ronnie in the Air

EQUIVALENT
COLORS 72

USING THIS BOOK

UNLIKE PAINTS, which can be premixed on a palette, pastel colors have to be overlaid or blended together on the paper itself. The purpose of this book is to provide the pastel artist with an easy guide to nearly 600 color overlays. In addition, the effects of four different colored papers are shown for each one, thus creating over 2000 color mixing effects. The experienced pastellist knows that a very large range of colors can be created by blending or overlaying pigments, but hopefully this book will suggest some new combinations, while for the beginner, it offers help in selecting a basic palette from

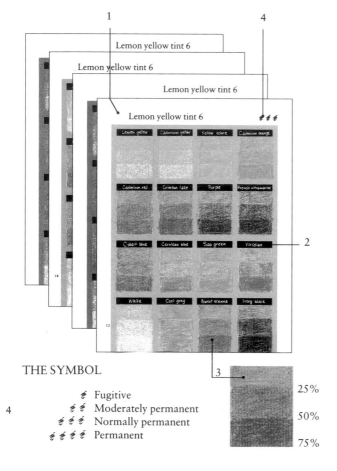

◄ *In pastel work, the color of the paper plays an important part, so four different ones have been selected for the color charts.*
Each set of four pages features one of 13 chosen colors, referred to as the "main" color (1). For a visual guide to these, see pages 1 and 2. Each main color is overlaid by 16 constant "basic palette" colors (2, and see opposite), which are repeated on every page. Every color combination is shown in three different proportions of pigment to paper, approximately 25%, 50% and 75%, achieved by varying the pressure on the pastel stick (3). The symbol (4), appearing on the first page of each color, denotes the degree of permanence of the main color (some pigments are slightly more lightfast than others).

THE SYMBOL

♪ Fugitive
♪ ♪ Moderately permanent
♪ ♪ ♪ Normally permanent
♪ ♪ ♪ ♪ Permanent

25%

50%

75%

◄ *This is the basic palette used throughout the book, shown without the addition of the main color.*

1 *Lemon yellow tint 6*
2 *Cadmium yellow tint 4*
3 *Yellow ocher tint 6*
4 *Cadmium orange tint 6*
5 *Cadmium red tint 6*
6 *Crimson lake tint 4*
7 *Purple tint 4*
8 *French ultramarine tint 8*
9 *Cobalt blue tint 6*
10 *Cerulean blue tint 4*
11 *Sap green tint 5*
12 *Viridian tint 6*
13 *White (cream shade)*
14 *Cool gray tint 4*
15 *Burnt sienna tint 6*
16 *Ivory black*

REMEMBER

*The main color is featured **four times**, once on each of the colored papers. The basic palette repeats once on each page.*

the many choices available. Soft pastels have been used throughout, and the paper used for the color charts is Ingres, which is one of the most popular pastel papers.

THE BASIC PALETTE

Some pastellists work with a very large range of colors – though however many you have, there is always some shade in nature which does not correspond with a color in your collection. The book seeks to show that even with a quite small range of colors, or basic palette, the permutations are enormous. Our basic palette of 16 colors is shown above, but this is only a suggested starting point. You may wish to substitute or include other colors. Only by experiment can you discover the palette that suits you best.

OVERLAYING AND BLENDING

LAYING ONE COLOR on top of another creates a third color, as shown on this page. Thus two primary colors, such as yellow and blue, or red and yellow, will make secondary colors — green and orange. The tertiary colors, browns and grays, which are a mixture of three primaries, are achieved by adding the third primary to the secondary color. The ways in which overlays are achieved are many, depending on each artist's way of working. The examples shown on the opposite page provide some ideas.

CREATING SECONDARY AND TERTIARY COLORS

Cadmium yellow and crimson lake overlaid to produce orange

Lemon yellow and cerulean blue produce a clear, bright green

Ultramarine and crimson lake produce purple

▶ *The tertiary color is shown where the three circles overlap*

COMPLEMENTARY COLOR OVERLAYS

▶ *When two complementary colors, which are those opposite one another on the color wheel, are "mixed", they create a range of neutral browns and grays.*

Cadmium red and viridian

Crimson lake and sap green

Lemon yellow and purple

Cobalt blue and cadmium orange

Cerulean blue and cadmium orange

BLENDING COLORS

▶ *Colors blended with a torchon. This implement will mix colors very thoroughly, but it is only intended for small areas; if used too fiercely or over a large area it may scratch into the pastel.*

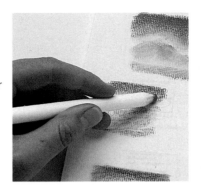

ABOUT PASTELS

Soft pastels are made from a single pigment or a blend of pigments bound with gum. Lighter tints are produced in the manufacturing process by adding whiteners, such as chalk and china clay, and darker shades by adding black. Each make of pastel varies in the ingredients used, the range of colors and the number of tints or shades of each color. The numbering systems, which denote the colors and their tints and shades, also vary. Daler-Rowney, the brand used here, give each color a name and number, e.g. Yellow ocher 663. The tint variations are numbered 0–8 (though no color has as many as nine variations). The lower the number, the paler the tint.

▼ *From left to right: Viridian and crimson lake blended with a torchon, a finger and cotton wool.*

▶ *A soft sable brush has been used to blend the colors here.*

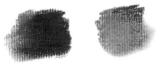

▼ *Soft effects can be created by using a putty eraser to blend colors. Use it lightly, taking care not to remove the top layer of color.*

GREENS

GREENS ARE ONE of the trickiest of colors to mix, because nature provides such a large variety — greens range from near-blacks and deep, rich olives through subtle blue-greens to brilliant, acid, almost yellow greens. If your main interest is landscape you may in time have to add a few more pastel colors to your range, but these pages show some of the many variations you can achieve with the basic palette. Notice that if you mix two slightly "cool" colors such as lemon yellow and cerulean blue, the green will be clear and sparkling, while two "warmer" colors such as cadmium yellow and ultramarine, which have a slight bias towards red, will give a denser, duller color. Don't forget that your choice of colored or tinted paper will also affect the result.

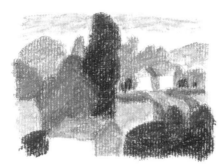

◀*Picture made using the mixes opposite for all the greens.*

Ivory black
Lemon yellow

Ivory black
Cadmium yellow

Purple
Lemon yellow

◀*Other ways to make greens and greenish shades. Don't forget that it makes a great difference what order the colors go down in. Generally, darker colors first, yellows on top unless a very dark shade is required.*

Purple
Yellow ocher

Cadmium orange
Cerulean
Lemon yellow

Cadmium red
Cerulean
Lemon yellow

8

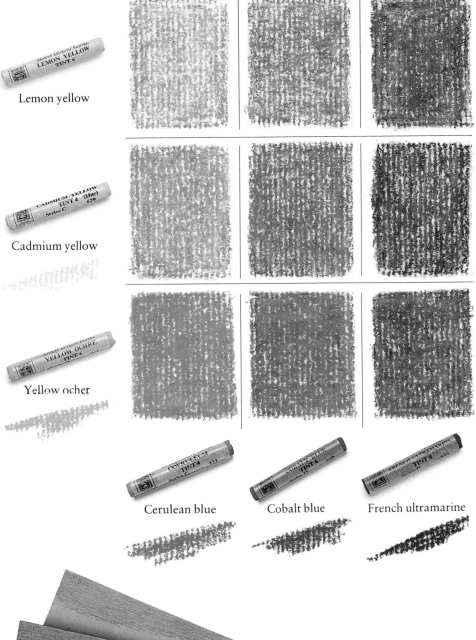

Lemon yellow

Cadmium yellow

Yellow ocher

Cerulean blue Cobalt blue French ultramarine

9

SKIN TONES

WE TEND TO THINK of skin as basically pink, cream or brown, but in fact skin tones vary enormously even within the same ethnic group. The lighting conditions also make a great difference; for instance, in shadowy areas, pale skins can look bluish, greenish or mauve, while dark skins could seem greenish brown or purple-black. Pitching the tonal value correctly is at least as important as finding the "right" color. And you may find yourself using quite surprising colors to indicate certain nuances of light or shade.

Much can be done with a very few colors — in fact it is best to keep your palette simple, especially at first.

▶ *This portrait was drawn with charcoal on cool gray paper and then colored with yellow ocher, crimson lake, purple and white. Cerulean was the main eye color, but was softened with white and purple. White was used delicately but extensively, with gentle finger blending to achieve softer passages. Shadowed areas were done with the same colors, but with more purple and less ocher and white.*

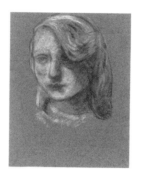

Main blend for lit area white over a small amount of crimson lake over yellow ocher

Main blend for shadow area white over crimson lake over purple

Variations also used
1 White over crimson lake over yellow ocher
2 White over yellow ocher
3 White over yellow ochre over purple
4 White over crimson lake over purple

10

There are many different formulas for painting flesh — artists invent their own palettes based on observation, personal preference and style — so take these charts as a guide only.

A *Very dark complexions*
1 Burnt sienna over ultramarine
2 Orange over black
3 Burnt sienna over black

Shadows
4 Burnt sienna over ultramarine over black
5 Viridian over cadmium red over black

Highlights
6 White over cadmium orange over purple
7 White over cerulean over burnt sienna

C *Olive complexions*
1 Gray over cadmium yellow over burnt sienna
2 White over orange over purple
3 White over orange over cerulean

Shadows
4 Cobalt blue over cadmium red over yellow ocher
5 Orange over purple

Highlights
6 White over yellow ocher
7 White over yellow ocher over cerulean

A

B

C

D

B *Mid-brown complexions*
1 Yellow ocher over burnt sienna
2 Orange over burnt sienna
3 Gray over burnt sienna

Shadows
4 Burnt sienna over cobalt blue
5 Orange over ultramarine

Highlights:
6 White over cerulean over yellow ocher
7 White over cerulean over crimson lake

D *Pale complexions*
1 White over yellow ocher
2 White over crimson lake over cadmium yellow
3 White over orange over cerulean

Shadows
4 White over crimson lake over cerulean
5 White over cadmium yellow over purple

Highlights
6 White over cerulean
7 White over cadmium yellow

11

Lemon yellow tint 6

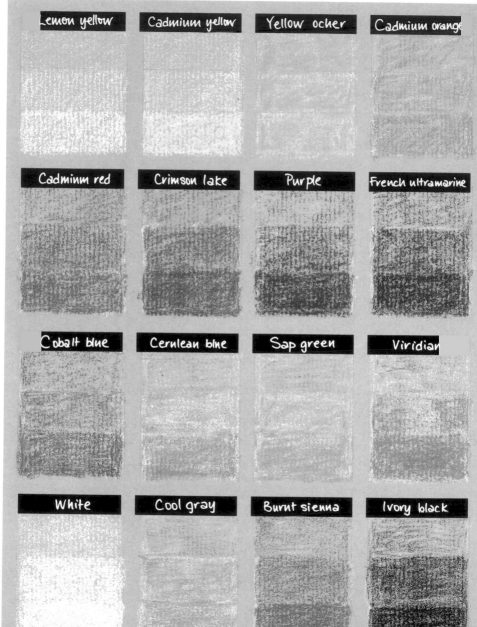

Lemon yellow	Cadmium yellow	Yellow ocher	Cadmium orange
Cadmium red	Crimson lake	Purple	French ultramarine
Cobalt blue	Cerulean blue	Sap green	Viridian
White	Cool gray	Burnt sienna	Ivory black

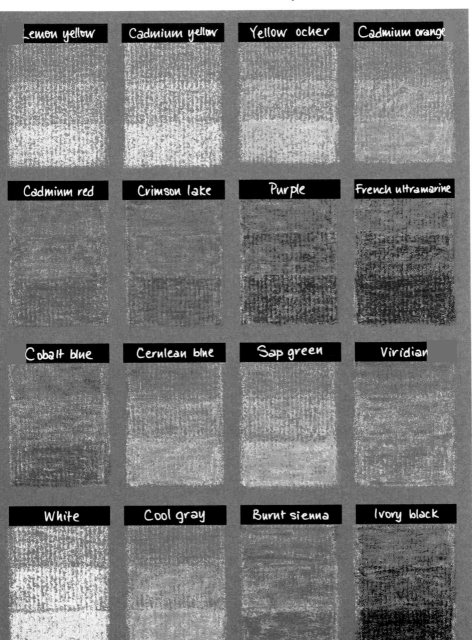

Lemon yellow | Cadmium yellow | Yellow ocher | Cadmium orange

Cadmium red | Crimson lake | Purple | French ultramarine

Cobalt blue | Cerulean blue | Sap green | Viridian

White | Cool gray | Burnt sienna | Ivory black

13

Lemon yellow tint 6

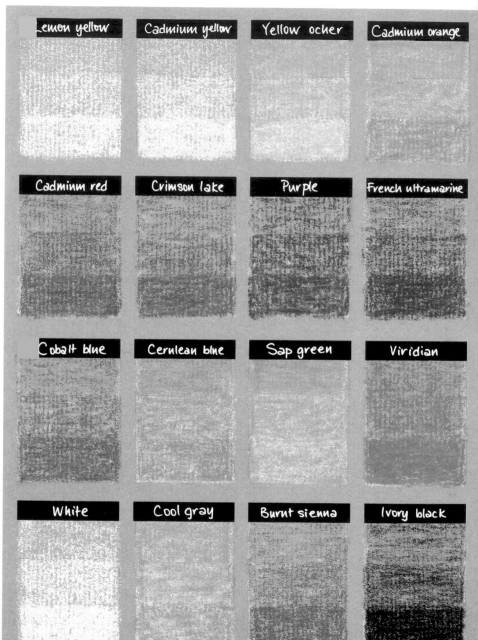

Lemon yellow	Cadmium yellow	Yellow ocher	Cadmium orange
Cadmium red	Crimson lake	Purple	French ultramarine
Cobalt blue	Cerulean blue	Sap green	Viridian
White	Cool gray	Burnt sienna	Ivory black

Lemon yellow tint 6

Lemon yellow	Cadmium yellow	Yellow ocher	Cadmium orange
Cadmium red	Crimson lake	Purple	French ultramarine
Cobalt blue	Cerulean blue	Sap green	Viridian
White	Cool gray	Burnt sienna	Ivory black

Cadmium yellow tint 4

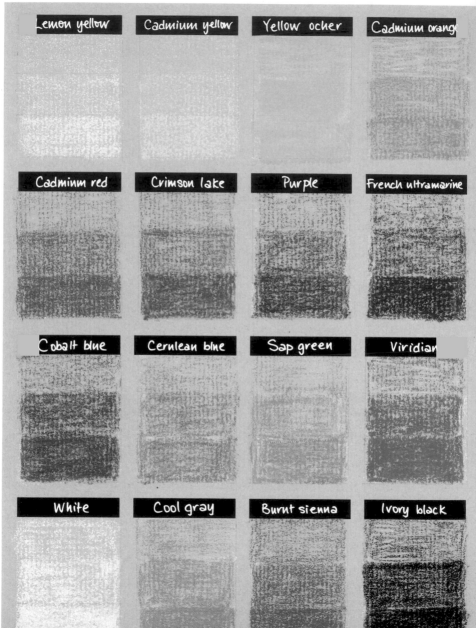

Lemon yellow

Cadmium yellow

Yellow ocher

Cadmium orange

Cadminm red

Crimson lake

Purple

French ultramarine

Cobalt blue

Cernlean blue

Sap green

Viridian

White

Cool gray

Burnt sienna

Ivory black

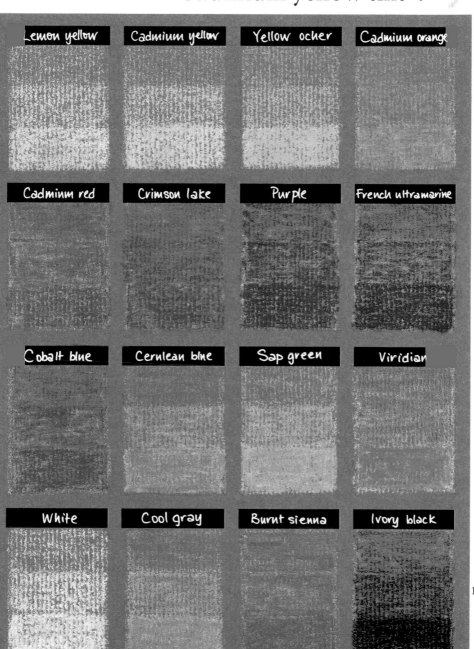

Cadmium yellow tint 4

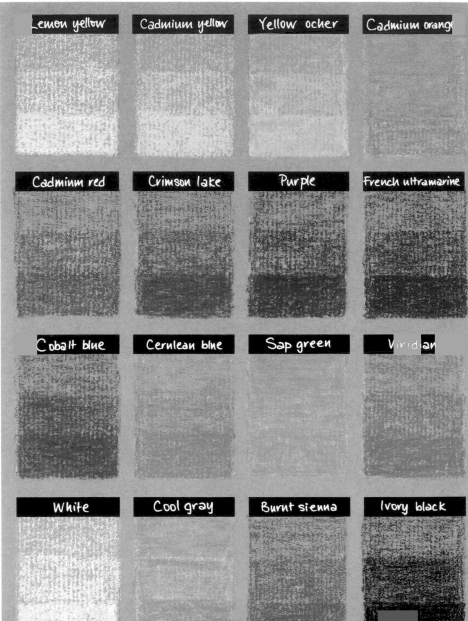

Lemon yellow	Cadmium yellow	Yellow ocher	Cadmium orange
Cadmium red	Crimson lake	Purple	French ultramarine
Cobalt blue	Cerulean blue	Sap green	Viridian
White	Cool gray	Burnt sienna	Ivory black

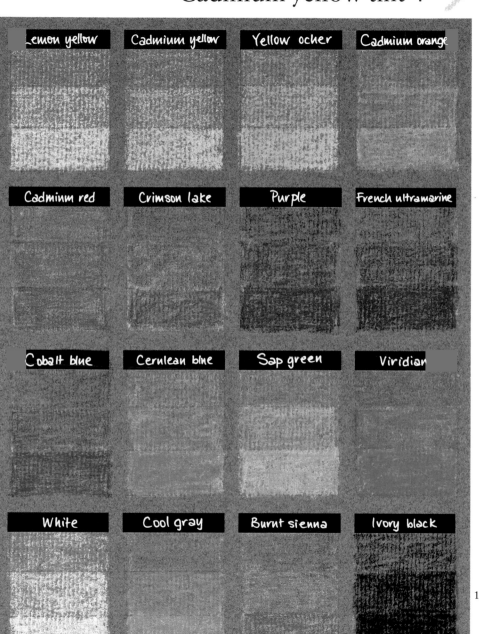

USING COMPLEMENTARIES

Sally Stride – *Oak in Winter*

14 x 20 ins

IN THIS SCENE the slanting winter light is conveyed by use of warm and cool violets and warm yellows, punctuated by vivid pinks and browns. Very speedily drawn on white paper, the colors are smeared or smudged into one another with fingers and then drawn over again so that the colors have a quality of being vigorously shaken or stirred together.

▲ *The far hill is drawn first in red violet and crimson lake, then softened to a haze with fingers and a liberal coating of pale violet. Either side are patches of pale and bright cadmium yellow rubbed into underlying pale mauves.*

▶ *The oak tree is drawn in brown, black and crimson, seemingly dissolving as color is dragged into surrounding areas by the movement of the pastel.*

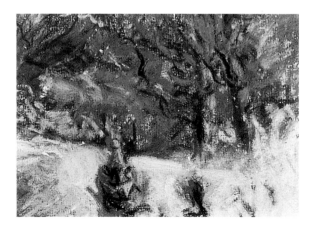

▶ *The active, almost frenzied marks of the pastel sticks give light and energy to the pale gold foreground. Trees are backlit, in greenish brown and black, and color spills over the paper as light over the landscape.*

20

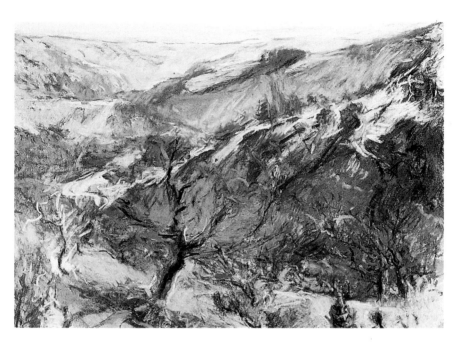

The light treatment of the sky shows clearly how the artist puts down one color, rubs it lightly to soften it, and then overlays it with a second, third or fourth color.

Lemon yellow	Cadmium yellow	Yellow ocher	Cadmium orange

Cadmium red	Crimson lake	Purple	French ultramarine

Cobalt blue	Cerulean blue	Sap green	Viridian

White	Cool gray	Burnt sienna	Ivory black

Lemon yellow	Cadmium yellow	Yellow ocher	Cadmium orange

Cadmium red	Crimson lake	Purple	French ultramarine

Cobalt blue	Cerulean blue	Sap green	Viridian

White	Cool gray	Burnt sienna	Ivory black

Cadmium orange tint 6

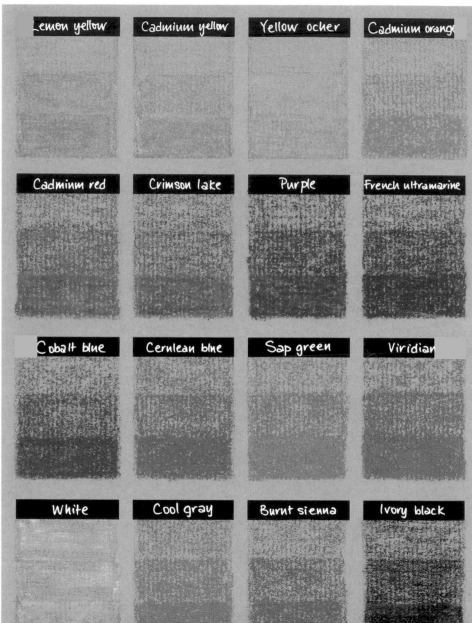

Lemon yellow	Cadmium yellow	Yellow ocher	Cadmium orange
Cadmium red	Crimson lake	Purple	French ultramarine
Cobalt blue	Cerulean blue	Sap green	Viridian
White	Cool gray	Burnt sienna	Ivory black

Cadmium orange tint 6

| Lemon yellow | Cadmium yellow | Yellow ocher | Cadmium orange |

| Cadmium red | Crimson lake | Purple | French ultramarine |

| Cobalt blue | Cerulean blue | Sap green | Viridian |

| White | Cool gray | Burnt sienna | Ivory black |

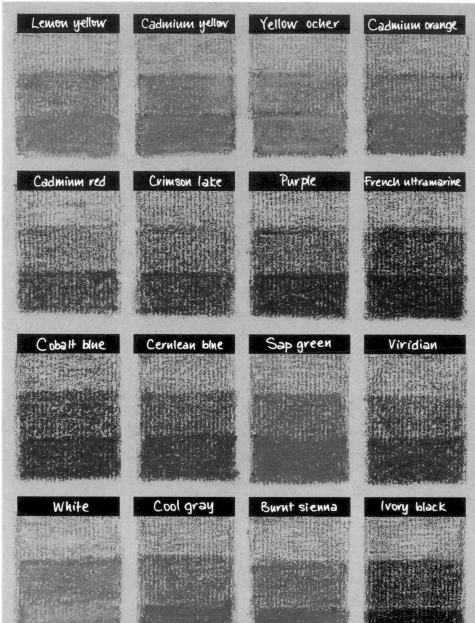

Lemon yellow	Cadmium yellow	Yellow ocher	Cadmium orange
Cadminm red	Crimson lake	Purple	French ultramarine
Cobalt blue	Cerulean blue	Sap green	Viridian
White	Cool gray	Burnt sienna	Ivory black

Cadmium red tint 6

Lemon yellow	Cadmium yellow	Yellow ocher	Cadmium orange

Cadminm red	Crimson lake	Purple	French ultramarine

Cobalt blue	Cernlean blue	Sap green	Viridian

White	Cool gray	Burnt sienna	Ivory black

Cadmium red tint 6

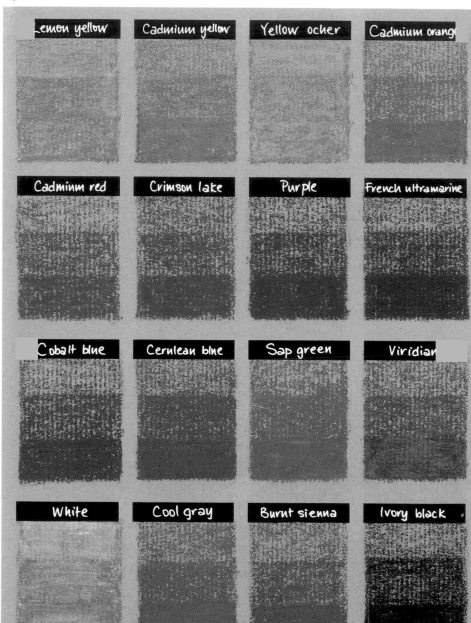

Lemon yellow	Cadmium yellow	Yellow ocher	Cadmium orange
Cadmium red	Crimson lake	Purple	French ultramarine
Cobalt blue	Cerulean blue	Sap green	Viridian
White	Cool gray	Burnt sienna	Ivory black

Lemon yellow	Cadmium yellow	Yellow ocher	Cadmium orange

Cadmium red	Crimson lake	Purple	French ultramarine

Cobalt blue	Cerulean blue	Sap green	Viridian

White	Cool gray	Burnt sienna	Ivory black

Crimson lake tint 4

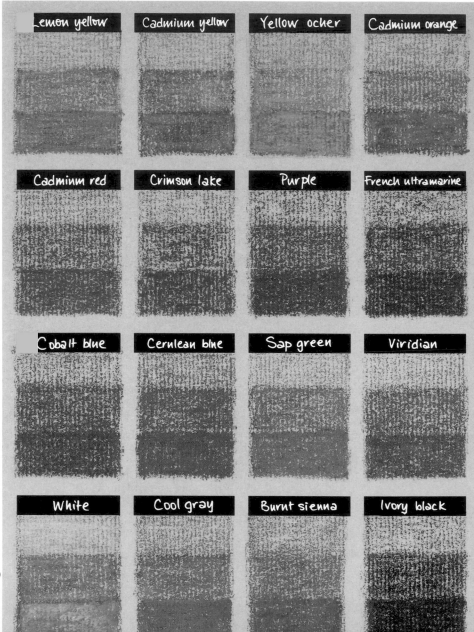

Lemon yellow	Cadmium yellow	Yellow ocher	Cadmium orange
Cadminm red	Crimson lake	Purple	French ultramarine
Cobalt blue	Cerulean blue	Sap green	Viridian
White	Cool gray	Burnt sienna	Ivory black

Lemon yellow	Cadmium yellow	Yellow ocher	Cadmium orange

Cadminm red	Crimson lake	Purple	French ultramarine

Cobalt blue	Cernlean blue	Sap green	Viridian

White	Cool gray	Burnt sienna	Ivory black

Crimson lake tint 4

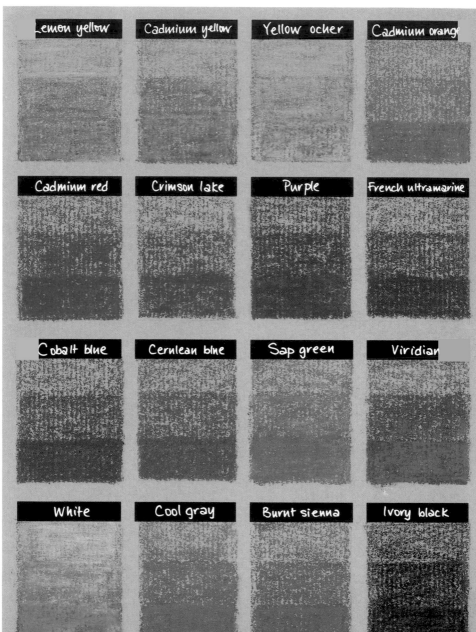

Lemon yellow	Cadmium yellow	Yellow ocher	Cadmium orange
Cadmium red	Crimson lake	Purple	French ultramarine
Cobalt blue	Cerulean blue	Sap green	Viridian
White	Cool gray	Burnt sienna	Ivory black

Lemon yellow	Cadmium yellow	Yellow ocher	Cadmium orange

Cadmium red	Crimson lake	Purple	French ultramarine

Cobalt blue	Cerulean blue	Sap green	Viridian

White	Cool gray	Burnt sienna	Ivory black

THE COLORS OF SNOW

Margaret Glass – *Sun and Shadows*
11 x 15 ins

THE RICH TERRACOTTA PAPER used here provides a lively contrast to the otherwise cold palette. Its enlivening and color-enhancing effect is particularly noticeable in the cold snow shadows. The weak warmth of the sun and its reflection in the snow are suggested with pale cadmium yellow and touches of lemon yellow — no white is used. The picture is given unity by the way the snow colors are repeated more gently in the sky.

▶Dark cerulean is the main color for the snow shadows, highlit with blue-green and violet with sepia touches. For the sunlight, pale cadmium is accented with pale blue-green and pale violet.

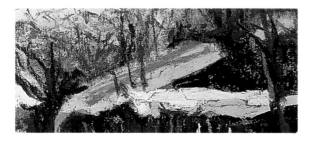

◀The thick wedges of snow on the sheds are mostly in the shade, so gray-violet and dark cobalt blue are used, but one patch is struck by sun, and here a thick, heavy stroke of pale cadmium is applied. Above, the distant trees are greenish gray and neutral gray over pale cerulean, much more gently drawn where the growth is delicate.

▶ Pale, cold cerulean, very pale violet and cadmium yellow are blended together to create the soft tints in the sky, over which tree branches have been gently and deftly drawn using gray-blue and gray-brown. Stronger tones or colors would have been too harsh.

34

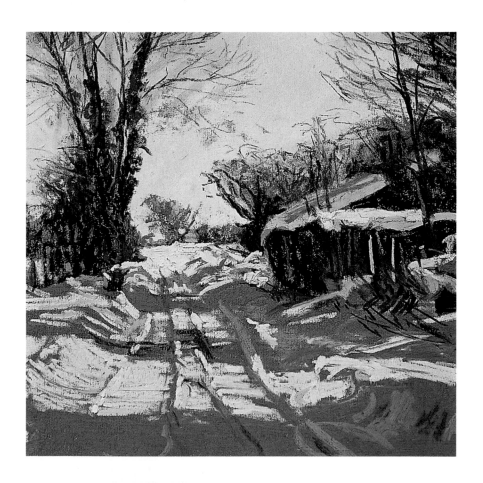

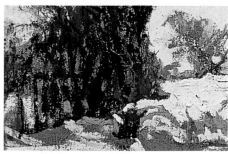

◀ *The hedgerow has been drawn in with red-brown, blue-gray, and sepia and black, while the snow clinging to the branches is depicted in cerulean. The red-brown paper plays an important role in suggesting light on trees behind the hedge.*

35

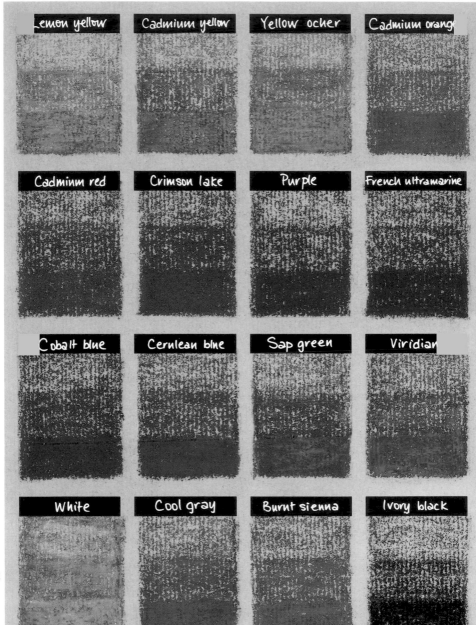

Lemon yellow	Cadmium yellow	Yellow ocher	Cadmium orange
Cadmium red	Crimson lake	Purple	French ultramarine
Cobalt blue	Cerulean blue	Sap green	Viridian
White	Cool gray	Burnt sienna	Ivory black

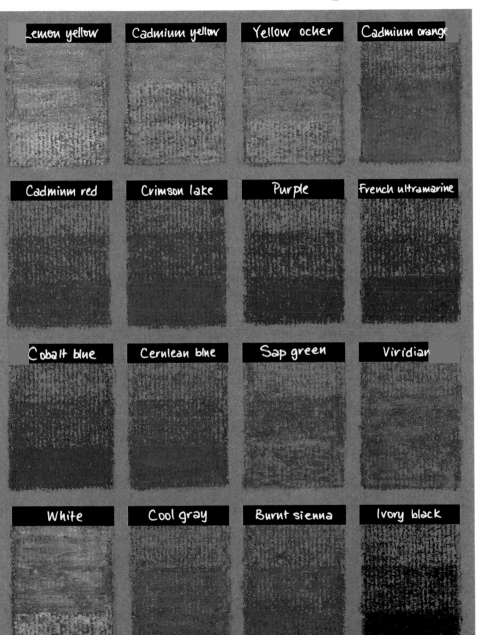

Lemon yellow	Cadmium yellow	Yellow ocher	Cadmium orange
Cadminm red	Crimson lake	Purple	French ultramarine
Cobalt blue	Cerulean blue	Sap green	Viridian
White	Cool gray	Burnt sienna	Ivory black

Purple tint 4

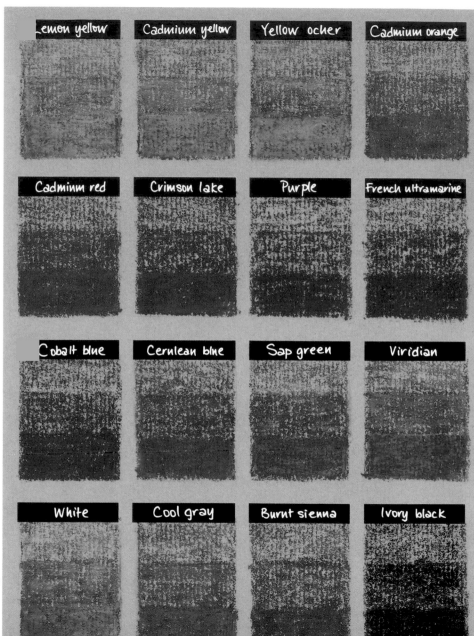

Lemon yellow	Cadmium yellow	Yellow ocher	Cadmium orange
Cadmium red	Crimson lake	Purple	French ultramarine
Cobalt blue	Cerulean blue	Sap green	Viridian
White	Cool gray	Burnt sienna	Ivory black

Lemon yellow	Cadmium yellow	Yellow ocher	Cadmium orange

Cadmium red	Crimson lake	Purple	French ultramarine

Cobalt blue	Cerulean blue	Sap green	Viridian

White	Cool gray	Burnt sienna	Ivory black

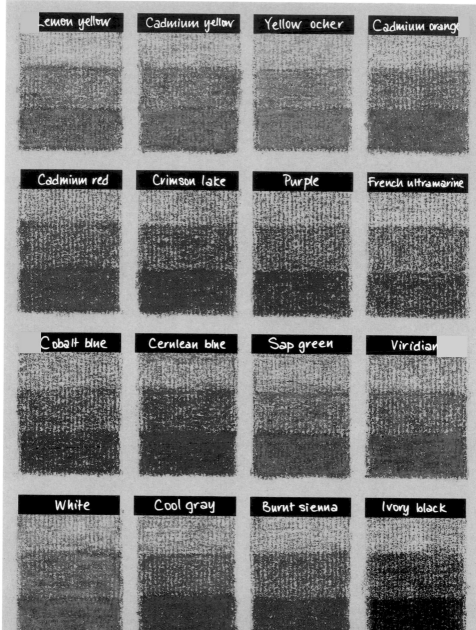

Lemon yellow	Cadmium yellow	Yellow ocher	Cadmium orange
Cadmium red	Crimson lake	Purple	French ultramarine
Cobalt blue	Cerulean blue	Sap green	Viridian
White	Cool gray	Burnt sienna	Ivory black

Lemon yellow	Cadmium yellow	Yellow ocher	Cadmium orange
Cadmium red	Crimson lake	Purple	French ultramarine
Cobalt blue	Cerulean blue	Sap green	Viridian
White	Cool gray	Burnt sienna	Ivory black

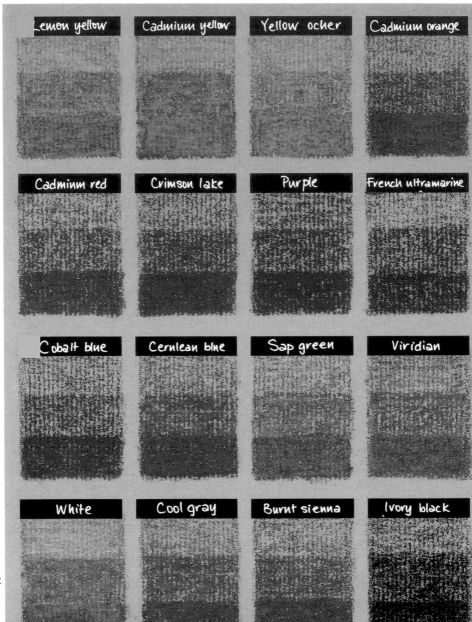

Lemon yellow | Cadmium yellow | Yellow ocher | Cadmium orange

Cadmium red | Crimson lake | Purple | French ultramarine

Cobalt blue | Cerulean blue | Sap green | Viridian

White | Cool gray | Burnt sienna | Ivory black

42

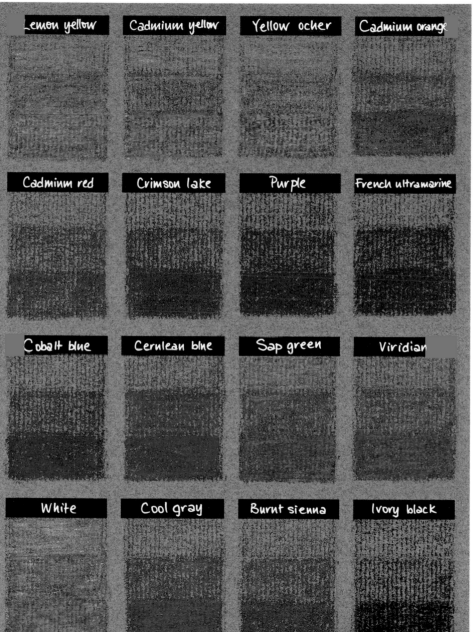

Lemon yellow	Cadmium yellow	Yellow ocher	Cadmium orange
Cadmium red	Crimson lake	Purple	French ultramarine
Cobalt blue	Cerulean blue	Sap green	Viridian
White	Cool gray	Burnt sienna	Ivory black

43

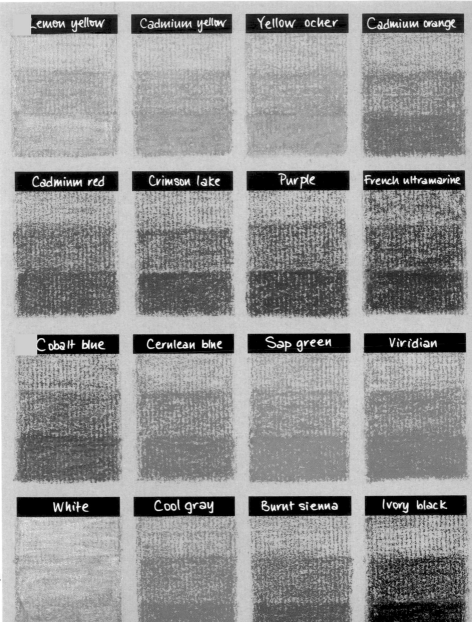

Lemon yellow | Cadmium yellow | Yellow ocher | Cadmium orange

Cadmium red | Crimson lake | Purple | French ultramarine

Cobalt blue | Cerulean blue | Sap green | Viridian

White | Cool gray | Burnt sienna | Ivory black

Cerulean blue tint 4

Lemon yellow	Cadmium yellow	Yellow ocher	Cadmium orange
Cadmium red	Crimson lake	Purple	French ultramarine
Cobalt blue	Cerulean blue	Sap green	Viridian
White	Cool gray	Burnt sienna	Ivory black

Cerulean blue tint 4

Lemon yellow	Cadmium yellow	Yellow ocher	Cadmium orange

Cadmium red	Crimson lake	Purple	French ultramarine

Cobalt blue	Cerulean blue	Sap green	Viridian

White	Cool gray	Burnt sienna	Ivory black

Cerulean blue tint 4

Lemon yellow	Cadmium yellow	Yellow ocher	Cadmium orange
Cadminm red	Crimson lake	Purple	French ultramarine
Cobalt blue	Cerulean blue	Sap green	Viridian
White	Cool gray	Burnt sienna	Ivory black

Viridian tint 6

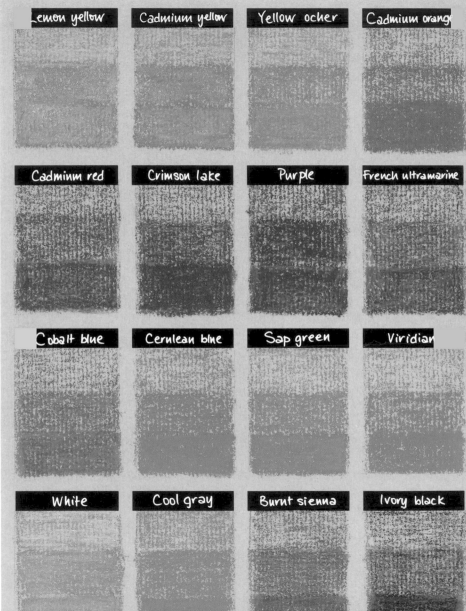

Lemon yellow

Cadmium yellow

Yellow ocher

Cadmium orange

Cadmium red

Crimson lake

Purple

French ultramarine

Cobalt blue

Cerulean blue

Sap green

Viridian

White

Cool gray

Burnt sienna

Ivory black

Lemon yellow	Cadmium yellow	Yellow ocher	Cadmium orange

Cadmium red	Crimson lake	Purple	French ultramarine

Cobalt blue	Cerulean blue	Sap green	Viridian

White	Cool gray	Burnt sienna	Ivory black

49

Viridian tint 6

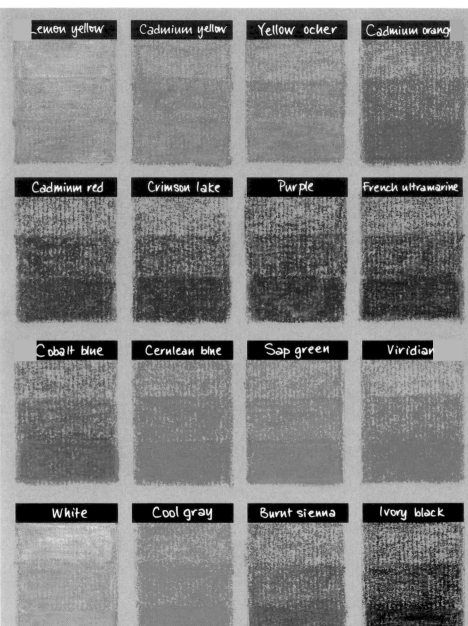

Lemon yellow	Cadmium yellow	Yellow ocher	Cadmium orange
Cadminm red	Crimson lake	Purple	French ultramarine
Cobalt blue	Cerulean blue	Sap green	Viridian
White	Cool gray	Burnt sienna	Ivory black

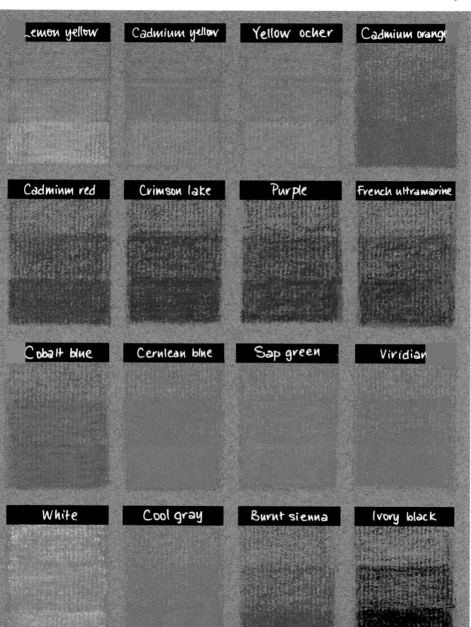

Lemon yellow	Cadmium yellow	Yellow ocher	Cadmium orange
Cadmium red	Crimson lake	Purple	French ultramarine
Cobalt blue	Cerulean blue	Sap green	Viridian
White	Cool gray	Burnt sienna	Ivory black

USING GREENS

Rosalind Cuthbert – *Cypresses, Fiesole*
21½ x 29½ ins

IN THIS STRONGLY LINEAR DRAWING viridian has been used as a base, with other greens laid on top. In many areas these have been overlaid with darker, cooler or brighter colors to increase tonal contrasts and thus heighten the dramatic atmosphere. The paper is a greenish brown, sufficiently neutral to appear pinkish through the greens and greenish through the pinks of earth and shadows. This imbues the applied colors with a gentle liveliness.

▼ *The trees on the left were drawn using the same greens — permanent green and Hooker's green — overlaid with ultramarine blue and deep turquoise, pale cream and pink. Trunks and branches are combinations of permanent rose and pale chrome green, providing a pale, warm contrast to the dark, cool masses of the foliage.*

◄ *The main color used in this part of the picture is viridian. The shadowed side of the tree has overlays of ultramarine and black, while the sunlit side is lightened with pale chrome green and lemon yellow. An outline of madder lake provides a lively edge which separates one dark tree from the next as well as suggesting the heat of the day.*

► *The pale English red ground is lightly dragged across the paper, allowing greenish paper to break through. Tree shadows of crimson, burnt sienna and ultramarine provide warm horizontal counterpoints for the main verticals of the composition.*

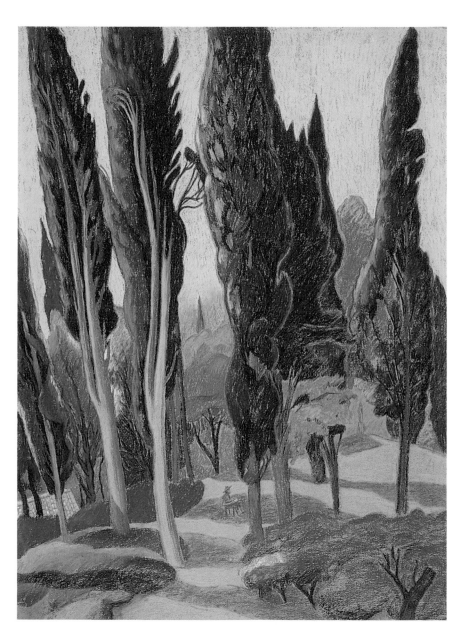

53

White (cream shade)

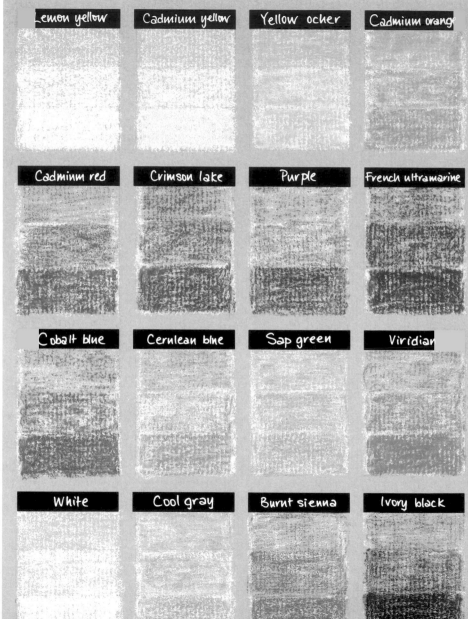

Lemon yellow

Cadmium yellow

Yellow ocher

Cadmium orange

Cadmium red

Crimson lake

Purple

French ultramarine

Cobalt blue

Cerulean blue

Sap green

Viridian

White

Cool gray

Burnt sienna

Ivory black

54

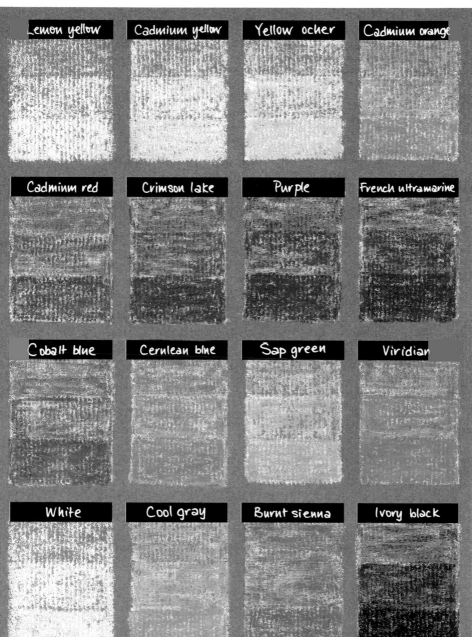

Lemon yellow	Cadmium yellow	Yellow ocher	Cadmium orange

Cadmium red	Crimson lake	Purple	French ultramarine

Cobalt blue	Cerulean blue	Sap green	Viridian

White	Cool gray	Burnt sienna	Ivory black

White (cream shade)

Lemon yellow	Cadmium yellow	Yellow ocher	Cadmium orange
Cadmium red	Crimson lake	Purple	French ultramarine
Cobalt blue	Cerulean blue	Sap green	Viridian
White	Cool gray	Burnt sienna	Ivory black

White (cream shade)

Lemon yellow	Cadmium yellow	Yellow ocher	Cadmium orange
Cadminm red	Crimson lake	Purple	French ultramarine
Cobalt blue	Cernlean blne	Sap green	Viridian
White	Cool gray	Burnt sienna	Ivory black

Cool gray tint 4

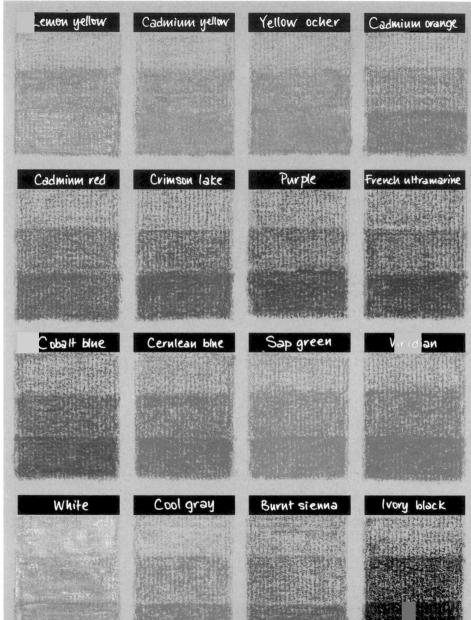

58

Cool gray tint 4

Lemon yellow	Cadmium yellow	Yellow ocher	Cadmium orange
Cadmium red	Crimson lake	Purple	French ultramarine
Cobalt blue	Cerulean blue	Sap green	Viridian
White	Cool gray	Burnt sienna	Ivory black

Cool gray tint 4

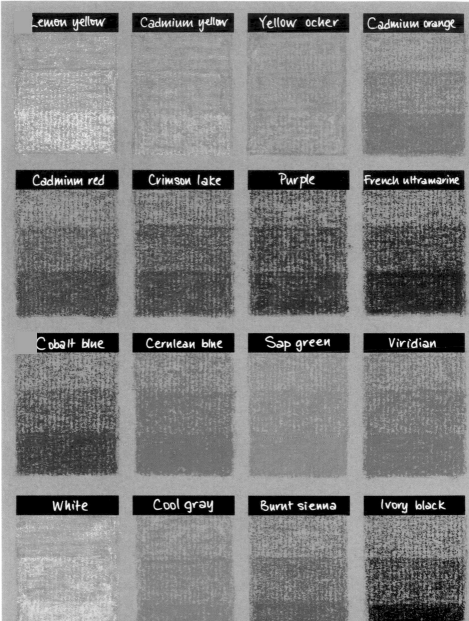

Lemon yellow	Cadmium yellow	Yellow ocher	Cadmium orange
Cadminm red	**Crimson lake**	**Purple**	**French ultramarine**
Cobalt blue	**Cerulean blue**	**Sap green**	**Viridian**
White	**Cool gray**	**Burnt sienna**	**Ivory black**

Lemon yellow	Cadmium yellow	Yellow ocher	Cadmium orange

Cadmium red	Crimson lake	Purple	French ultramarine

Cobalt blue	Cerulean blue	Sap green	Viridian

White	Cool gray	Burnt sienna	Ivory black

USING MUTED COLORS

Carole Katchen – *Ronnie in the Air*
27½ x 39 ins

THE PASTEL has been done on a cool gray paper, with the colors broadly hatched on and then lightly finger-blended. The whole surface is treated in this way, with white highlights added afterwards. The effect is light and energetic, in keeping with the subject. The palette is very simple — consisting mainly of gray, ocher, white and umber — but other colors have been smudged in too, further enlivening the surface.

▼ *Pink and mauve create soft shadows, warming up an otherwise cool color scheme.*

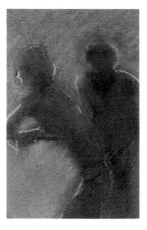

▲ *Empty areas of the composition effectively heighten the effect of movement by contrast. However, nowhere is the color completely flat; ocher and pale pink hatched together suggest gently vibrating light and air.*

▲*Vigorous finger-blending softens the forms to suggest distance.*

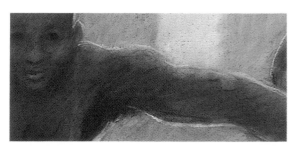

▶ *Umber, burnt sienna and gray are used to describe the bronze skin against the light.*

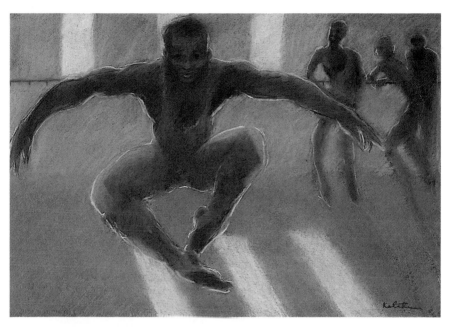

◀ *Ultramarine, Prussian
blue and crimson partly
smudged together form
the dancer's leotard. The
white outline suggests
speed as well as
emphasizing the
backlighting.*

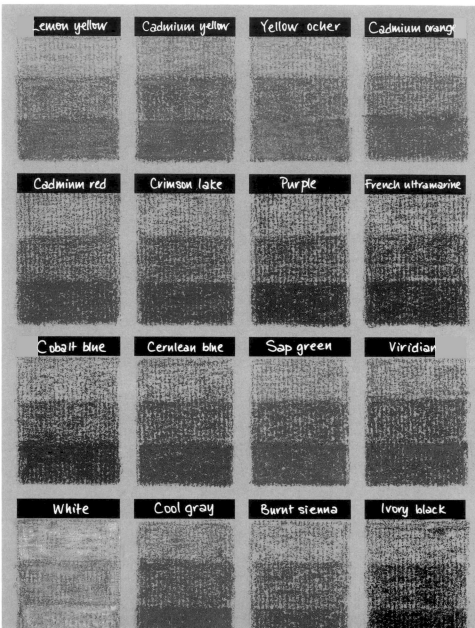

Lemon yellow

Cadmium yellow

Yellow ocher

Cadmium orange

Cadmium red

Crimson lake

Purple

French ultramarine

Cobalt blue

Cerulean blue

Sap green

Viridian

White

Cool gray

Burnt sienna

Ivory black

Lemon yellow	Cadmium yellow	Yellow ocher	Cadmium orange
Cadmium red	Crimson lake	Purple	French ultramarine
Cobalt blue	Cerulean blue	Sap green	Viridian
White	Cool gray	Burnt sienna	Ivory black

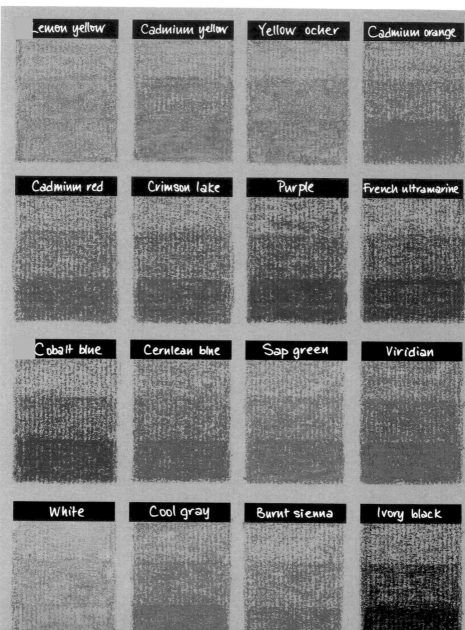

Lemon yellow

Cadmium yellow

Yellow ocher

Cadmium orange

Cadminm red

Crimson lake

Purple

French ultramarine

Cobalt blue

Cerulean blue

Sap green

Viridian

White

Cool gray

Burnt sienna

Ivory black

Lemon yellow	Cadmium yellow	Yellow ocher	Cadmium orange

Cadmium red	Crimson lake	Purple	French ultramarine

Cobalt blue	Cerulean blue	Sap green	Viridian

White	Cool gray	Burnt sienna	Ivory black

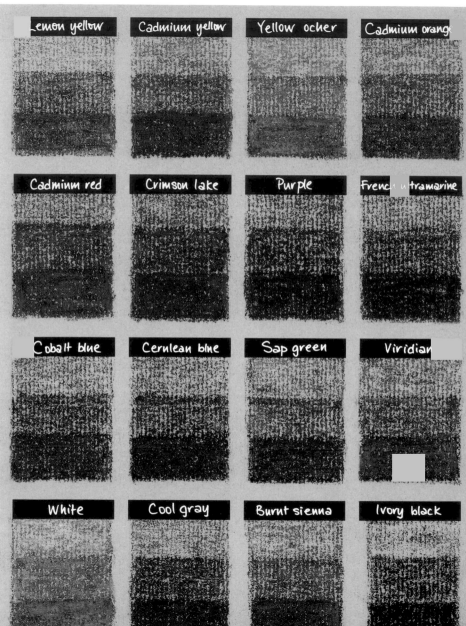

Lemon yellow

Cadmium yellow

Yellow ocher

Cadmium orange

Cadmium red

Crimson lake

Purple

French ultramarine

Cobalt blue

Cerulean blue

Sap green

Viridian

White

Cool gray

Burnt sienna

Ivory black

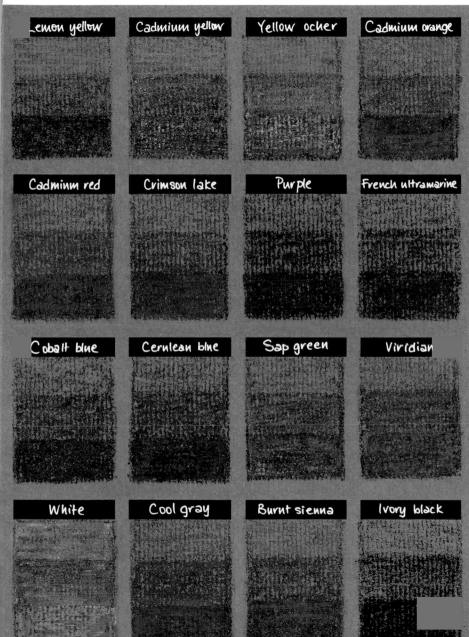

Lemon yellow	Cadmium yellow	Yellow ocher	Cadmium orange
Cadmium red	Crimson lake	Purple	French ultramarine
Cobalt blue	Cerulean blue	Sap green	Viridian
White	Cool gray	Burnt sienna	Ivory black

Ivory black

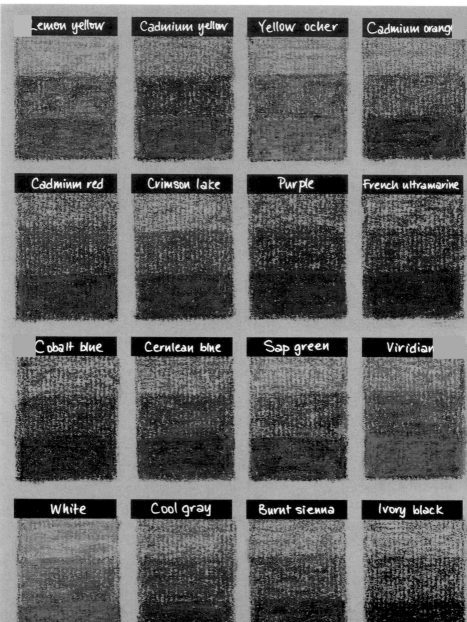

Lemon yellow

Cadmium yellow

Yellow ocher

Cadmium orange

Cadminm red

Crimson lake

Purple

French ultramarine

Cobalt blue

Cerulean blue

Sap green

Viridian

White

Cool gray

Burnt sienna

Ivory black

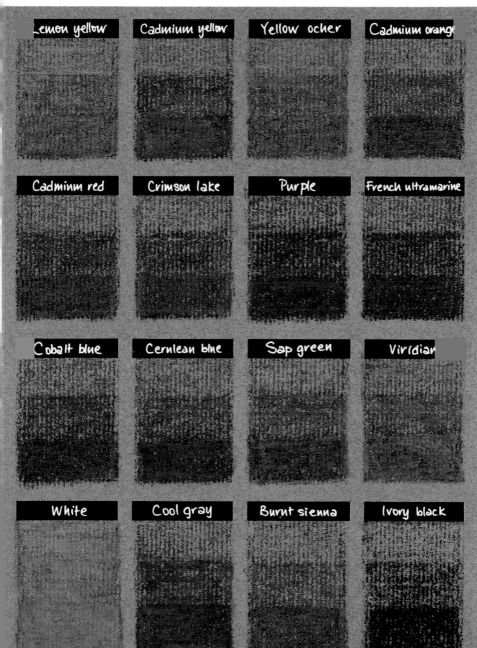

Lemon yellow	Cadmium yellow	Yellow ocher	Cadmium orange
Cadminm red	Crimson lake	Purple	French ultramarine
Cobalt blue	Cernlean blne	Sap green	Viridian
White	Cool gray	Burnt sienna	Ivory black

EQUIVALENT COLORS

ROWNEY	REMBRANDT	SCHMINCKE	SENNELIER
Lemon yellow tint 6	Lemon yellow 205,5	1 lemon Sunproof yellow D	Lemon yellow
Cadmium yellow tint 4	Light yellow 210,5	Sunproof yellow 2 light H	Cadmium yellow light 300
Cadmium orange tint 6	Orange 235,5	Sunproof orange H	Cadmium yellow orange 196
Cadmium red tint 6	Permanent deep red 371,5	Permanent red 3 deep B	Vermilion 80
Crimson lake tint 4	Carmine 318,5	Carmine red D	Helios red 682
Purple tint 4	Blue violet 548,5	Bluish violet B	Blue purple 281
French ultramarine tint 8	Ultramarine deep 506,5	Ultramarine deep D	Sapphire blue 620 or Ultramarine blue 388
Cerulean tint 4	Phthalo blue 570,5	Greenish blue B	Coeruleum 259
Viridian tint 6	Permanent green deep 619,5	Light green B	Viridian 250
White (cream shade)	White 100,5	White	White
Cool gray tint 4	Bluish gray 727,7	Gray blue H	Yellow gray green 497
Burnt sienna tint 6	Burnt sienna 411,5	Burnt sienna D	Dead leaf green 141
Ivory black	Black 700,5	Black	Ivory black